MASTHEAD

MANAGING EDITOR
Jenna Gersie

PROSE EDITOR
Rose Alexandre-Leach

POETRY EDITORS
Anna Mullen
Ellie Rogers

VISUAL ART EDITOR
Anna Martin

PUBLISHER
Dede Cummings

COVER ART
"Sustain" by Amy Guidry
Acrylic on canvas, 12 x 12 in., 2015
"Sustain" originally appeared in The
Journal, *Issue 40.3*

FOR QUESTIONS AND COMMENTS
editor@hoppermag.org

hoppermag.org
facebook.com/hopperlitmag
Twitter & Instagram: @hopper_mag

The HOPPER
A LITERARY MAGAZINE FROM GREEN WRITERS PRESS

LETTER FROM THE EDITORS

The Lost Boys of Neverland, upon learning that it is their potential mother (Wendy) whom they have shot from the sky, and upon panicking that they have lost her forever and realizing they cannot safely carry her to their underground house, resolve to build a mossy house around her as she heals, complete with roses and a chimney. The survival of our home planet, complete with its roses, storms, disputed boundaries, marches, slowing currents, chimneys—all of its familiar and all of its sea change—demand such uncanny, subversive, and sometimes desperate turns of thought regarding how we understand house, home, and habitat—and how we make and tend them. As editors it has been a joy to array a collection of such experiments in this, our third issue.

Ecesis has an etymology you can really burrow into. *Oikos*, Greek for "house," gives us *ecology*: the study of the home; *economy*: the management of it; *eccumenical*: the worldwideness of it, and, of course, *ecesis*: the making of it.

It is such fun to offer artists a tight kernel of a word, one often relegated to specific contexts of scientific literature, and to watch them soak, distend, and ply it into queries of the moving body, speculations on inhabiting another's body, questions for the long dead, liminal slips or headlong charges into other habitats, studies of creatures adjusting to disturbance, inks and oils and lights exploring architectures of loss, newness, and memory. A musing on extraterrestrial agriculture echoes a song attending a newborn earth. Many dwell on the fertile overlap of wordsmithing and worldsmithing in how language fashions habitat. Always speculative in some sense or another, sometimes retro-speculative with a revisionary hunger or a warm wistfulness, these works unfold homecomings and home-leavings of all sorts.

Here are urgent celebrations of phenologies, and of the season of a single arc of dawn or afternoon; incantations for the freedom of migration and movement of humans, animals, and rivers alike; inquiries into violence and the arbitration of lines; challenges to speciesism. In their arrangement: an insistence that these all are forged in the same seedhead.

Could there be more crucial, fruitful work?

The Editors

ECESIS

noun | ece·sis | \ i-'sē-səs , -'kē- \

the establishment of a plant or animal in a new habitat

ᴛʜᴇ HOPPER

CONTENTS

DAVID LLOYD

Open House

What say we give up?
Fling open doors and windows,
leave wide the chimney flue?

Pull down screens,
rip the tongue from the groove,
crowbar shingles from the roof?

Burn fly-swatters. Bury insecticides,
pesticides, and assault weapons
in a steel coffin.

No vacuuming. No sweeping.
No sponging—not even skin.

Let dust roll its ghostly basketballs
across a threadbare floor.

Let stars invade our space.
Downpours on mattresses,
sunlight on sconces.

Welcome the field mouse to the cheese board,
cockroach to the carvery,
bedbug to the duvet,
snake to the wine cellar.

Birds swoop without concussion.
Raccoons scour the stovetop with quick tongues.
And everyone drinks from the toilet.

Give over to the ant's carpentry,
the wood wasp's spelunking,
the nesting swallow's mud-packing,
the orb spider's corner wizardry—

What say we leave unmolested
that drip hanging from the tip
of the blade of grass?

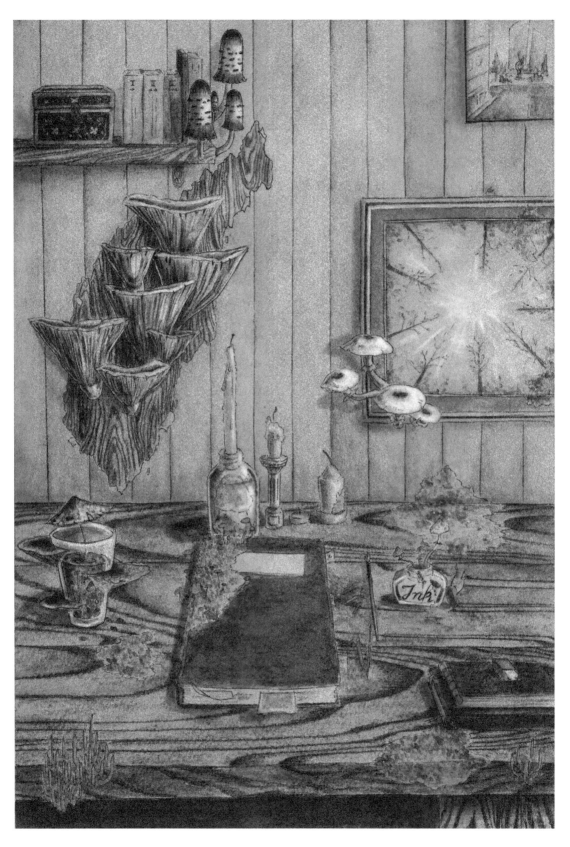

And we'll be there | SARA MASSIDDA
Mixed media (watercolor, ink, and digital), 8 x 12 in., 2017

Triolet

Outside the cottage, in the shrub, a deer sits
with fawn, eating beach plums and hiding
from the midday sun, which is hot but keeps mosquitoes
outside the cottage in the shrub. A deer sits,
complacent; it owns this island. When the beachgoers
are gone, the bright umbrellas packed, litter thrown
outside the cottage—in the shrub, a deer will sit,
with fawn, eating beach plums unhidden.

JOANNA BRICHETTO

What White Tree Is Blooming Now | NONFICTION

IT STARTED. The procession of trees. The trees don't move, but the white does: white tree blossoms, from species to species. First, in late February and if not charred by sleet, come white flowers of star magnolia. Stinky Bradford pears are next, trees so ubiquitous in corporate landscapes (and invasive in natural ones) that when they froth white, even people who don't notice trees notice. Then, dogwood. Everyone loves dogwood. Serviceberry, hawthorn, black cherry, yellowwood, black locust, and so on, week by week of the rolling spring, one white tree bloom after the other. It won't stop till summer, and by then, who is watching? By then, Nashville is a weedy jungle and we stay inside to escape the chiggers.

But I'll be watching. The procession is important. There are rules: only white, only trees, and only where I can see them while I go about my business. I call it the Order of Worship.

The Order of Worship sounds religious because it is, and I may sound religious but I am not. The phrase was suggested by my favorite secular humanist Jew and it hit the right note in my Protestant past—just the right chord of awe, ceremony, and gratitude. Blossoms are both the object of wonder and the celebrants.

Order of Worship is just a framework to borrow. Structure keeps me sane when spring is crazy. A frame is an edge, a corner to grasp when the greens slide by too fast. Because spring doesn't turn on like a switch. It sneaks. *How long has the chickweed been blooming in the grass? Was this violet open yesterday?* Spring's first slow teases give hope this year will be different, will be the year I can note every swell, give every bud burst its due, yet still keep my head. And then spring flies. Away. Erupts, more like. And suddenly, I've lost my head and footing. I am under green water. My own backyard is foreign. The park trail where every bank was an old friend is a dark, leafy tunnel and not an altogether friendly one.

But the Order of Worship helps. I can sort one

category of miracle into place: white trees and when they bloom. I can compare progression from year to year. I can hold on.

Last Friday, a few fat, fuzzy buds on the star magnolia split, froze, then rallied during the weekend's warmth so that today they've all burst into frenzies of their own snow. Even last night's wind only whipped off a few petals. Tomorrow will find more on the pavement, and a hard freeze may burn them, but right now, this moment is the star magnolia's star turn.

Star magnolias aren't native trees and therefore do not function deep and wide in our habitat, but they are polite. Educational, too. Low suckers make good show-and-tell on urban nature walks, and buds are big enough for kindergarteners to dissect in the school lot. We poke nestled layers of petal, sniff the sweet lemon meant to lure pollinators. After budburst, flowers are floppy, lank, like used tissue. But when viewed en masse, distributed on leafless twigs and especially on branches pruned for horizontal reach, they make exquisite tableaux. Even a trash alley is a Japanese painting if there's a full-blown star magnolia at the curb. It is the prelude tree in the Order of Worship.

Let me back up. The general, liturgical concept of "Order of Worship" has existed thousands of years, but I first met it as the stated outline in the bulletins of a childhood church. The progression from prelude to postlude was fixed, ritualized. Signposts included the Apostles' Creed and Lord's Prayer, the offering and doxology, scripture, sermon. Mercifully, it also included Mrs. Child's baked-fresh-that-morning white loaf as Body of Christ. There has never been a tastier Jesus. But whatever the signposts and progression, the structure's function was to guide pew-bound congregants on a journey to deeper connection with a greater power.

White trees also follow an order. The progression depends upon weather and climate and how biodiverse the viewing range—a few invasive bullies can spoil everything—and it unfolds because it unfolds,

not because it is trying to lead us anywhere. Each tree does its own thing in its own time. The only "deeper connection" at work is the connection between a tree's reproductive bits and a successful pollinator, because to reproduce is a tree's prime directive. I am far more comfortable with this type of order.

Frankly, the pious overtones of Order of Worship are putting me off right this minute. But what other frame is as useful? I could fabricate an Order of Wonder, but where's the heft of history, the music of metaphor?

I could call the whole thing phenology and be done. Phenology is the study of key seasonal changes year to year. I'm interested in all changes, which is why the transition from winter to spring nearly kills me, but my white tree project is just a tiny, arbitrary subset: just one cherry-picked project out of a zillion other observations. And I'm not at the careful data collection stage yet. I'm in a far more subjective phase where I need to see beautiful blooms happen, and happen consecutively: when one tree finishes, another kind starts. I need to know the magic keeps spinning, and along recognized paths. I need to know what to expect and where.

Let's get back to what is compelling: trees with spring flowers winter white. We can call the white pure, holy, or at least clean, but no matter the adjective, white is easy to spot in an interstate verge. That's where I first noticed parts of the Order, driving on I-40, glancing at the unmowable flanks of overpasses and ramps, seeing creamy clouds in the tangle of trash trees.

The Order goes like this, but timing is fluid: star magnolia, Bradford pear, serviceberry, roughleaf dogwood, flowering dogwood, hawthorns, rusty blackhaw, American plum, black cherry, black locust, yellowwood, oakleaf hydrangea, fringe tree, Southern magnolia, catalpa, persimmon, basswood, sourwood, farkleberry. (Farkleberry is my favorite to say aloud.) The Order fattens or lengthens as I find new trees. Last year, I had no idea my kid's school had three serviceberries behind the teachers' parking lot. The year before that, we found a yellowwood on a walk we'd taken hundreds of times.

The Order is diverse. Some are native, some not; some are "desirable" landscape material, some not. Some are familiar specimen trees; some are tucked on hillsides off-trail in the woods. Some you don't notice till tiny flowers fall at your feet, some are in-your-face obvious, and some are smelled before seen.

Bradford pear blooms stink like dirty socks (and worse)—but black locust blooms are heaven. The first spring at our first grown-up house, I staggered through the backyard, face lifted, trying to breathe my way toward the source of something new: not honeysuckle vine, not star jasmine, but along those lines, and definitely with a hint of the Hawaiian White Ginger Splash I bought from an Avon lady when I was twelve. Perfume ghosted every breeze and was especially haunting at twilight. Black locust, as I later knew it to be, is sweet but deep, resonant: one of those creamy, heady florals no adjective can satisfy and that makes me want to press fistfuls of blooms to my face and swoon. I'd wake improved, somehow, and with no chiggers despite full body contact with lawn.

From inside a moving car on the interstate, black locust flowers are seen and not smelled. But if you walk your dog atop an overpass, you might get both. And if you know about the hole in the fence where the homeless guy, the stoner kids, and the coyotes have worn a packed path, you can stand below trees and pluck spent blooms from the grass. Most will be small bouquets nipped by squirrels, still sturdy enough to stand in a juice glass to perfume the house a few more days. Each tiny flower is papilionaceous, butterfly-shaped and exquisite, as per other members of the bean family (like sweetpeas, redbud), and wet with nectar to call butterflies, ants, and bees. Black locust honey, or acacia honey, is said to be divine.

Bees lead me to another possible frame for the order of white. Beekeepers record the dates of nectar and pollen sources within a foraging area, and I've read this can be called a Floral Calendar. Or the less poetic "Floral Inventory." My so-called Order of Worship is a calendar and inventory too, but of my own foraging zone, restricted to color, to trees, and to my own fancies. When I ask my local bee friend about the Floral Calendar, she says that in real life beekeepers simply talk to each other about "what's blooming now." No need for metaphoric framework. How practical. My version could likewise be "what white tree is blooming now."

I still vote for Order of Worship as most useful term. It wins despite the implied religiosity and because of it. Because this is the cultic language I

reach for to describe the higher power that is a flower. As long as I don't get too literal assigning liturgical signposts to tree species, I can deal. My exception is for the prelude, because you have to start somewhere.

You have to finish somewhere, too. At the bottom of every mimeographed church bulletin was the phrase, "Worship ends, Service begins," which made no sense. Was it a recurring typo? Hadn't we just survived the service, which was now, *at last* ending, not beginning? Later, I understood service could be verb as well as noun. The phrase implied we had worshiped together, and we were now expected to go out and serve. Fine, but how do I serve my trees?

By trying to see them, learn about them, write about them. I'm afraid I'll come off as evangelical (heaven forbid), but I should invite others to see. I should invite you to find your phenological order wherever your foraging range may be: whether it's a park or a parking lot, a driveway, a city block or the interstate median. To look around at "what's blooming now."

Our service is to deepen our connection to the place around us, and to our place in it. This is greater power enough. And it can start with one bud on one tree, no matter the color. ❧

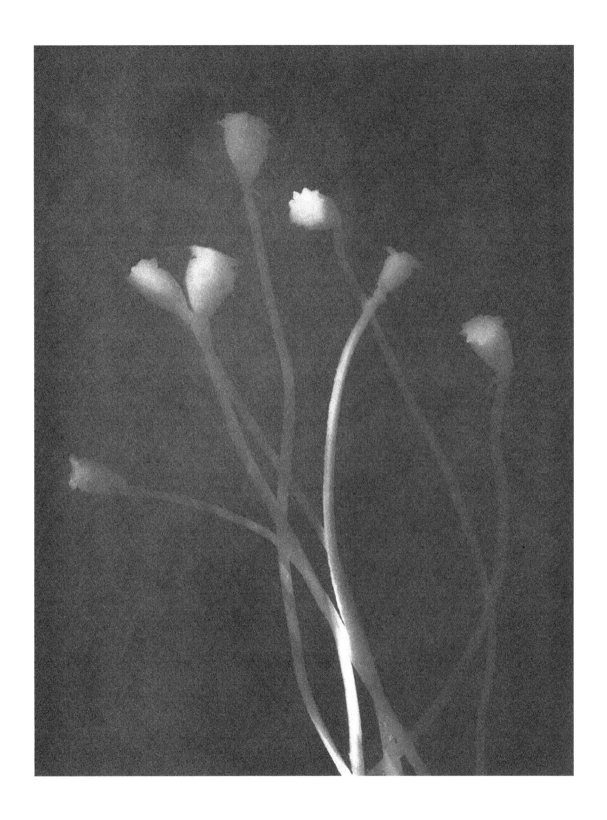

Poppy Seed Heads (*Papaver orientale*) | Alexis Doshas
Botanical cyanotype, 14 x 16 in., 2015

Laura Ingalls Wilder, Age 5,
Considers the Causes of Exile and Migration

Having moved with her family to Kansas
from Wisconsin woods, by way of
Missouri, but before her father's lease
on the new farm was revoked for lying
on the Osage Diminished Reserve
in her early girlhood, she waded
through the bluestem grass, trying
both to sway, and to stay upright.

Behind the gray-brown house, she found
nests of fleeing mice, who ignored
her apologies and appeals to come back.
Quail too, launched from their hatchlings,
leaving them to scatter under the thatch
and in her chest, she could feel
the percussion of wings.

And once, ferrets—which she scared off
with her careless steps, and they were like
threads of a dream: traceless, slippery
in the dim light under the grass
and almost gone before one knew
they were ever there.

Everything leaves, she thought:
grasshopper, milkweed seed, V of geese
—pushed by wind, cold, hunger
or a shadow beyond
reckoning.

Traffic | NONFICTION

Switchbacking the mealy drifts and softening ice slicks, I found dry rock where I could, comforted by Shannon's ease upon my shoulders. Though she was six now and had yet to say a word, her intuition often plugged that gap. As soon as we'd stepped off the lip toward Narragansett Bay, she'd arrested her bodily fidgets in deference to sensed perils underfoot. Besides, it was time. Equinox had passed, and with the gusty, blizzard-heavy winter finally giving way, the billow of sun, salt, and windless water numbed us through.

Out front, past the outcrops exposed by low slack, the fowl seemed likewise dazed. Eiders, a thousand or more split in three rafts, bobbed in lazy solace, shaking off the months of pounding swells and frozen spray that sheared breakers away in sheets. Up top, Shannon shifted. A pair of gulls, silent, yellow-billed, materialized above, tracing sleepy, downward circles to see what they might steal. Unsatisfied, they made their way over an eider clan and settled, blanching into the white-backed drakes' patchy albedo.

Bottoming out, I tucked into a favorite channel that only low tide allowed. Winter hadn't changed a thing. As we came to the top of the tide pool chain, Shannon bounced on my shoulders, then kicked up her feral vocalizing. Other than shoulder rides, splashing is the only thing that engages her beyond a few seconds, and she threw a leg over my head, hooting and rasping like an owl wrestling a mink. Picking out a bare patch among the mops of bloated bladderwort, I sat her by still water, where she nestled in, dunked a hand, and tasted. Months of chlorine and soapy bathwater evaporated, and her smile pulled one out of me.

"Salt, Shan. Salt."

Stirring and licking, she quieted, fixed by the sea lettuce draping the slipperier rocks all around. We hadn't seen green in five months, let alone so much so deep. Trapped sunlight blurbed about each verdant ribbon like bulbous organisms coming out of winter. Whatever they etched in me, Shan's wordless mind took a deeper hit. She was gone, and I settled on a rock, listening to the feeble swells hush in and out of countless crevices.

Twenty yards off another duck, tiny, squirted through glassy water, flaring its white head patch. A male bufflehead, another winter resident. He didn't wait long for his harem, turning to watch four dusky hens snap through the surface. Popcorn ducks, Shan's little sister Flannery calls them. Soon, maybe today, they'd be off, bound for Canada.

The five ducks turned in unison, pat-patting pink feet before lifting toward the eiders. They'd heard what I did, something I hadn't in years: air popping its valve. Slick, smooth, and gray, the big-eyed seal head cut a wake around tilted slag. Sipping breath, it dimpled beneath, then as suddenly returned, launching on an outcrop twenty yards away. I hadn't been this close to one since leaving Alaska, when Karen called years before to say she was pregnant. The animal slid forward, stopped, then lowered its head, deflating into kelp and sun. Like the ducks, it had its calendar. Soon enough the pods would bunch, finning out of the bay for northern pupping waters.

❧

In Alaska, I saw the seals mostly from afar. Lined in their liturgies, they crowded the deltas or speckled the ocean just outside, pilfering thronged fish. Sometimes, though, I'd hear those breaking valves close by a canoe or near shore. A head would rear, look, and it wasn't hard to see it, that old Celtic notion of seals as drowned souls. They'd made a new life, mostly at sea, human when it suited, coming ashore to seduce, kidnap, or play, depending.

Once, in early March, I took a canoe up a small, winter-desolate river. I hadn't seen anyone in days, and coming out of the headwaters, I hit the estuary at peak tide. A few sea-run rainbows, steelhead, ghosted calm water beneath overcast skies. Drawing a stroke, I drifted toward a tight school, scattering them like well-whacked billiard balls, though I was their lesser

demon, as just offline of the canoe a submerged, shadowy bulk glided upriver.

Inverted, it rolled, close enough to poke with the paddle, then lifted its lids, where dark glass looked into me. Flippers flapped and it was gone, silent. I wasn't a threat, but creatures live by what they see, what they remember, what ancestry couches in mythology. The Natives there, the Tlingits, still hunt seals, and a handful of times I watched limp bodies lumped onto skiffs. Looking upriver, I saw the steelhead chaser peer down from bankside alders a hundred yards north. It turned and I turned, and it seemed that was it, though years later, maybe ten, Shannon dipped beneath lake water for the first time. Swimming, somehow, comes easy, and as her little form breasted open-eyed for the surface, all I saw was that seal.

*

With meltwater seeping downslope, the day lazed on. Focused on the tide pool now, Shannon gazed cock-eyed at the countless ringlets made by flickering fingers. When the water stilled, she re-showered, astounded by patterns whose nuanced distinctions I'd never see. With each spray she hunched over, extending her arms, working ten fingers to shape whatever she saw in those ripples. Hers was about the only motion around. Catatonic, the eiders moved just enough to hold position, while having drifted back in, the buffleheads swayed in like moratorium. The seal, too, seemed dead. Stuffed with squid, maybe a few flounder, its mottled form blended into rock. If I hadn't seen it haul out, I wouldn't have seen it at all.

*

We met a woman across the bay, a mother whose teenage son has similar afflictions to Shannon. No words, spoken or understood. Little grasp of, or maybe interest in, customized human bustle, either our practical protocols or kaleidoscopic subterfuge.

Such people are uneasy curiosities, revenants from our outset, before language and all that ensued pried us loose, but to passersby they remain just that, primitive baubles, and are as quickly dismissed.

Parents, though, maybe through bias, see more. Orbiting their wordless kids as moons might white dwarves, they lock in, wordless themselves, imbibing through gravity influences language can't grant, and this mother had an identical perception to my own.

"Seals. Whatever thoughts flow through his mind are seals, swimming deep. They're his world, but I'll never know, hear, or understand them."

"My God," I said. "Me too."

With the bay so still, I looked down at Shan, at the wresting fingers, the splashes, her concentration, and speculated on that flippered shadow and light coursing her depths. Unbarnacled by words, by any history but her own, they silk the dark fluid unimpeded, free-forming cosmologies neither I nor anyone I know would think to conceive.

I've read seals have gone back. If fossils can be believed, seals and whales and all the rest were on our trajectory, leg-bound, but for some reason turned, inhabiting two realms now, water and air.

As she does, Shan eventually roared. All that input bundles tight, needing release, and she let it out in declarative fashion, re-animating the buffleheads while startling a purple sandpiper, who lifted out of a nearby crevice, peeled away, then re-stationed a few ledges down.

With a huff, the seal turreted its head our way, shuttering those black eyes once, then twice. In kind, Shannon reared her own head, swiveling it side to side. So much of the day it seems she has a wasp's eyes, a dragonfly's, dialing her hexagonals to find the proper frame. Fixed, she tilted, snapping a shot of her own. God knows what they saw in one another, but doesn't God, all of it, traffic in that unbent light between us? The seal oozed forth, making hardly a crease as it slipped back to water. *

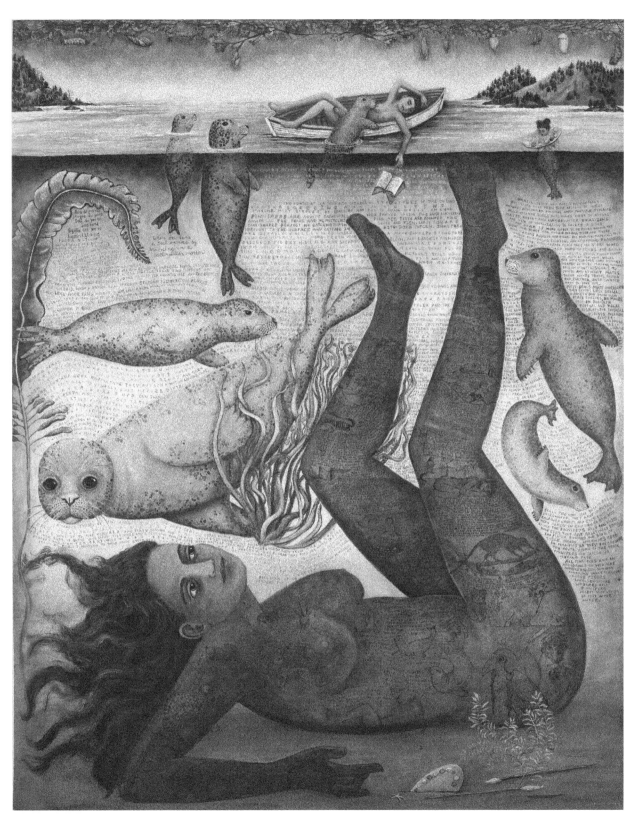

Reverie of the seals | Irene Hardwicke Olivieri
Oil on wood panel, 43 x 34 in., 2018

Butterfly Meeting | ALEXIS DOSHAS
Black-and-white selenium-toned silver gelatin print, 16 x 16 in., 2017

Wreck of the Michigan: *An Inquiry*

with thanks to Ginger Strand

In 1827, to attract tourists, hotel owners in Niagara Falls loaded up the schooner Michigan *with wild animals and sent it over the Falls; as many as 20,000 people came to see the grand spectacle.*

You set off on your horse in search of the cargo you won't quite find:
the most ferocious beasts of nature—panthers, wildcats, wolves.
Easy enough to shoot some, but you need them alive.
You peer after shadows and snapped
twigs, feeling watched. The New World
is still new, the wilderness a dense green belt
around Niagara, inscrutable. Did you curse the folly
of your mission? Question this need to touch, to prove?

❧

Was it like heaving a branch into rapids—its bumpy progress downriver
oddly fascinating? Like dropping a bright leaf off a bridge
then running to the other side to see if it appears?

❧

I keep dreaming I can touch the feral cat who lives in our house.
We have caught her, coaxed her, made her love cushions, windowsills,
treats from our hands, but her eyes gleam wild when you get
too close. In my dreams her fur, the color of bark and leaves,
is soft, and she never runs. Was it like that?

❧

Was it the hypnotic churn of whitewater, its glassy sinews
wrapping and wending over rock?
To see how your own bones might crush?
Maddening, how you could saunter to the brink of wildness
but no farther. That white, cold power—
the only place you couldn't go.

❧

Nine years old, at a Plymouth Plantation schoolhouse:
on the ledge below the chalkboard, I find a small blue egg.
No one looking, I pick it up, test it between thumb
and forefinger—part of the display,
like everything else, I think.
You thought you couldn't scratch
the wildness of this continent, thought surely the creatures would
swim to shore, shake themselves off, slip back into shadow
invigorated by the plunge. Of course
I squeezed until my blue egg shattered, real after all. Ashamed, surprised
and not surprised, I put it down, wiped my hands off, hoped no one
would see. Was it like that?—the new world more real,
more fragile than you ever imagined, its yolk
all sticky on your fingers?

Giraffe, Bronx Zoo | Lauren Grabelle
Archival inkjet print, 12 x 18 in., early 1990s

Galápagos Giant Tortoise, Museum of Natural History | Lauren Grabelle
Archival inkjet print, 12 x 18 in., early 1990s

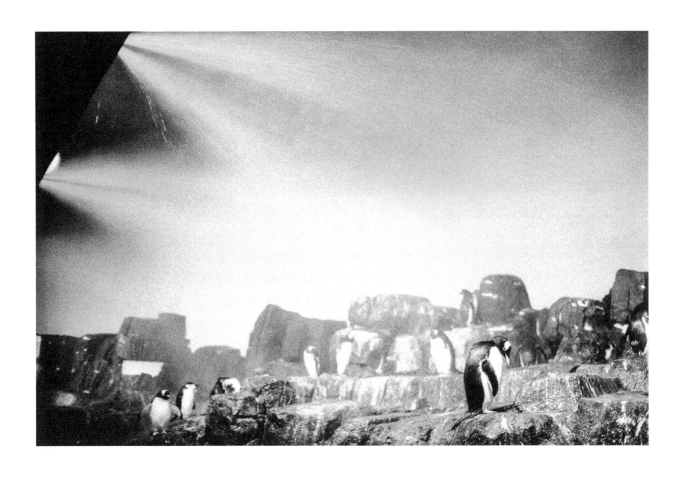

Penguins, Central Park Zoo | LAUREN GRABELLE
Archival inkjet print, 12 x 18 in., early 1990s

Elephant, W. 33rd Street | Lauren Grabelle
Archival inkjet print, 12 x 18 in., early 1990s

Scale

Season's architecture complete,
the mud dauber wasp
has retired.

 In this basement,
wings folded, she lets each of her six legs
feel its place on the cement floor. The furnace
hums them imperceptibly forward
without disturbing any part of her body—
antennae, head, thorax, thread of petiole
that keeps the pendulous abdomen
attached to the rest. The whole black body
with its yellow punctuation is smaller
than the dust devil
rolling across the floor.
 Before morning's end
she will advance to the dryer
where studs of blue jeans
snap against the drum, over and over,
as it makes its small metal circuit
in the machine,
 and as cars halted
at the stoplight on the corner throb
with stereophonic percussion, growling
impatience to resume their prowl
on the grand circuitry
that binds the earth
 as it spins
in its track around the sun,
a speck of dust
in the eye of the universe.

The petiole of a mud dauber
is composed
of 43 concentric corrugated layers.
From the top of the dryer,
it looks like an eyelash.

Succession

What they must have thought, pulling twine-rigged rafts
to the riverbank and cresting the scree
deposit cliff to an ensemble
of gopher frogs in the dark. How each unseen
thing was huge that night, even with
the specter of doubt casing their movement.
The weeks away from land folded
each moment back before letting it
become another, and the season
was balled up immediately after
it was read. It could have been shame they felt
those first overcast mornings, towing nets for fish
they weren't sure were there. Or maybe just after
deciding they were alone, they forgot
how hard it all was. But they get there in the dark.
That's what happens. They grope through a land
not theirs, and dawn ignites like a pilot light.

Succession

 Across the stippled center line
rushes a column of traffic in the same
 direction. We streamline each other,
 waked in parted air and hurried—
 offered, rather—to parallel inertias.

This is moving. I stop at a truck weigh
 station at dawn to watch a pair of turkeys
 saunter through the misted lot. They are tall
 and shimmer as they walk, and I want
to reach out and offer them the mill
 of my hand, a rudder through and away

 from this place. Take it. They disperse
 and I go. This is moving. Gentle hills
tease and part the rows of corn to disclose
 dirt scalps. The books in the bed of the truck
 are puffy from rain. They're going home.

 When I get there it won't be
the place I've imagined, but it's important
 to know that when I start unloading
 milk crates of books onto the driveway
 my mom will put out a hand. *Take them,*
she'll say. *They're yours now.*

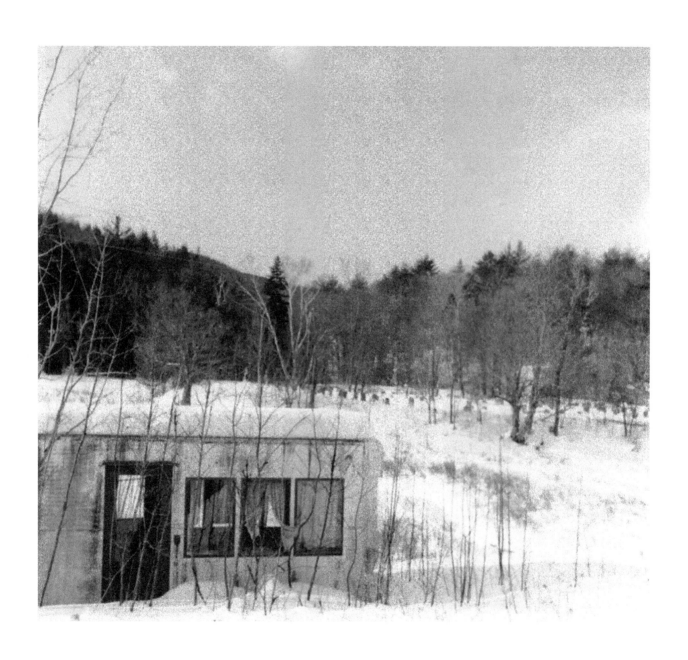

Abandoned Trailer & Cemetery | Alexis Doshas
Black-and-white selenium-toned silver gelatin print, 16 x 16 in., 2017

Northward | FICTION

I WAITED UNTIL I WAS SOBER TO READ YOUR LETTER. Writing back's something else entirely, and now I'm a bit drunk. I'd like to think that maybe it'll help. It's hard though, hard to speak across the thousands of miles, the plains and ranges and canyons and all that. This country swallows words, and if it ever spits them back up they don't mean the same thing. At least it does most words, which is just me saying ahead of time that I apologize if this letter comes out a dud.

As far as drinking goes, you might get a chuckle picturing me off scotch, but that's exactly what's happened, though beer remains a regular companion. Some days I drink a couple, some days more than a couple. The empties tell no lies, and maybe that's why we always shot our cans to hell. My shooting days are over now, save for a single eight-pointer I took last month, and that only to supplement what I've already smoked and stored. I've got no friends in town and hardly go there anyway. People die and people change and sometimes one looks like the other, am I wrong? What I'm saying is there's nobody judging me except myself, and I've given up on that, or at least I'm trying.

I read your letter three times, twice this morning and once again just now. It was long and kind and came as a real surprise, not altogether a welcome one, but of course I mean no offense and only mention it because I know you're not one for taking any. I'm friendless, that's all, with just this big blowing wind to talk to, not that I say much. When I do speak it bounces off something hard and comes right back, that or the wind takes it. My dog was hit by a car last year and it was sadder than shit but that's beside the point. The point is I'm fine with being sad, just like I'm fine with being alone. What makes it tough is the back and forth.

I've been moving toward this kind of life for a long time now, mostly as a result of my own choices, I suppose, but in a strange way even those feel less and less like mine to make. I can't say I looked forward to it, but I saw it coming, saw it growing like a storm over the lake. Now that I'm settled in I wish only for things to stay the same. It's steady alone, you know? The world's no bigger than what you see and smell and hear and taste. Past the toe of my boot there's the water, dead empty this time of year, and behind it the ridge. How your letter found its way over that ridge is beyond me.

So where to start? It's been a long fall and I'm thinking winter won't offer much better. Though the lake's just freezing up, and only in the smaller coves, the canoe's already begging for her nest up in the barn rafters. So many years I've pulled her from the cattails and set her there just beneath the roof to wait out the dark months like some kind of owl. That's winter I guess, awake but still, not really warm but at least not dying of cold. I'm not sure if it's better or worse knowing we're all in it together.

But here's the thing. I sold the barn six months ago, and now there's no turning back. The trailer went with it, and the acres. I even sold the truck. It was summer and seemed a fine idea, not that I thought it out, it just sort of happened. I moved my ice fishing shanty to the pine thicket on the south side of the point, set up a canvas tent for sleeping, built a bit of an outdoor kitchen. I figured I'd stay the summer and head south for a new start right about now. It's looking like I'm tucking in for a long run, though, and that's fine by me. Like I say, it doesn't feel much like my decision. You make one choice, way back, and from then on that choice makes all the rest. You see these things growing in front of you, slowly, slowly, and you paddle right at them, thinking there's always time to turn around.

That's the long way of saying this here's a new winter, unlike any I've known, and I've known more than most, but of course so have you. It sounds like maybe you're feeling it as well, at least that's what I got from your letter. When I opened it this morning I was sitting outside and the sun was coming off the page so bright I went blind for a minute. Then the words came back and I read it and I wondered if maybe our heads weren't linked up somehow despite all these years, all

the plains and ranges and canyons and such. It felt like maybe you knew what was happening over here because it was happening over there as well. You don't say it outright, but it feels like maybe that's why you're writing now rather than last year or the year before or any of those other years. I don't know.

I'm useless without fishing, I really am. Ice fishing's something, but it's not the same. Honest, we tell ourselves it's all water, it's all lake even when it's harder than brick, but I've humped brick and I've drifted in a boat and there's no confusing the two. And this year I won't even have the benefit of a wall to stand behind, or a bottle. I haven't moved in yet, but I'm thinking the bench in the shanty will serve as a bed once the real cold comes, which might be tonight, though I'm planning to stick it out in the tent as long as I can. Tending those lines will be a bitter business without the shanty, but I swear I'm useless without it, the fishing I mean. I wake early and my thoughts get me and I need something to do.

 I've been looking hard at this one tree trunk each morning when everything's gray. I've been looking at the long, sharp feathers of frost growing from the bark, the way two or three or four feathers grow together. Today at the end of the point I saw some broken twigs where moose browsed and are maybe browsing right now, though I doubt any animal would choose, if it had a choice, to be out in this night's awful wind. What's the point of all this noticing and looking? I'm not sure. It happens though, whether for something or not. You see one thing and then another and then you stand there staring and it's hard to turn it off.

A lot of things are hard these days. Bricks are hard. Ice is hard. The moose must be harder than shit. It's hard to believe all these years have passed and hard to believe the buds will burst again a few months from now, and by a few I mean seven, and that's me being generous. Still, I read my old journals and I know it happens. Phenology, they call it. Studying the seasons, the comings and goings, the deaths and births and slow sad circle of it all. My journals show it, or they tell it, and though I don't mean much by it, it seems I'm a journal myself nowadays. I've lived these changes and they've left their marks on my mind and across my hands. They've tracked blood across my goddamn snowy white soul like another deer hit wrong, whatever that means.

I've been reading some, not much, but a little, and in another couple weeks when I feel as though I've done what I can and the rest is up to fate and weather, I intend to read some more. That's where I got that phenology, from a book I've been sitting with here and there. You always read a bunch and I wonder if you still do. I'm sure you do. I'd like to thank you for all the books. At the time I didn't know they'd stick with me as they have, but they have. Just now I'm remembering the one that says writing letters is like dropping stones down a well, to which I'm inclined to say damn straight, though yours did make it here and I am responding. I don't remember the title of that one. I only remember it took place up north and the characters were always shivering.

The reading makes me think of you, but not just the reading. Out in the canoe, waiting there as one must, the mind wanders in ways you can't predict and wouldn't want to if you could. Out there listening to the waves, hearing a hundred voices in the slosh of one against the next, I think of you and I don't know why and I try not to question it. Just watch the memories go by, you know? You ever watch that train pass? I've decided it's safer not to hop it, but sometimes I can't help the urge.

That one cabin that one winter was good, and if you say otherwise I'll know you're a liar, but I know you won't say otherwise because I know you aren't a liar, and if you were at least you wouldn't lie about that. I swear the land has never been more cold and locked up and desperate, and I swear we're lucky to have survived. I promised myself never to go that far north again and I've kept that promise.

I wonder sometimes if it was us, our strength and our will. Back then I might have thought so, in fact I'm sure I did, but now it seems it isn't ever you, not you alone at least. It's that bigger something, not luck but something better, and bigger. That hard winter it was the cabin, and the stove, and the wood in the stove, and the lives that lay down at just the right time to give us food. And the food gave us warmth, and the warmth gave us strength, and with that strength we worked to find more food. It was so many things working to keep us warm, not happy but okay, and okay is enough.

I'm starting to feel drunker than I'd like, so I'm going to wrap this up, and I apologize for not having the wherewithal or whatever. I've got so much to say

and I'll never even begin to say it. I'll never say it all and so I won't even try.

If you could read the letters I've written, though, not letters like this but real letters, letters that say something real, well, if you could read those letters I guess you'd know. But those letters are out in the canoe, out on the lake and the river and at the mouth of the marsh and the tip of the point, out in my head when the light gets sad and golden and blasts all my thoughts to kingdom come. And they're on the end of the line when it goes tight and you pull like hell, they're there too if they're anywhere. Those letters never get written and they never could. I've written them, but not on paper.

Tomorrow I'm going to head out early, and when the sun comes around I'll know that somewhere the buds are greening and somewhere the days are growing longer. I'll look deep into that same old bark of that same old tree, where the frost seems to grow more elaborate than it should, longer and more fantastic than it should, and I won't ask why or how or where or when. The sun will hit the pines and the lake will kick spray. I'll put my hand down to touch the head of a dog that isn't there. I'll keep moving, get the gunwales in hand, and push off hard. You know better than most that there's always one more day on the open water, no matter how the ice gains on us, no matter how lonely, no matter how cold.

Warmest regards during this cold season, my friend. I'm not sure if it's the beers or what, but tonight I'm feeling okay about dropping these pebbles down the well, and for once I'm not afraid to say it outright. I miss you. Keep your hood up. Keep your nose up. There's something out there and it's got our name on it and won't take no for an answer. The wind's blowing from the north, and that's the way we're heading. So keep it to the wind my friend, and I'll do the same, and I'll pray we both rest well at night no matter what comes, no matter what dreams we do or do not have.

I'll do that right now. Pray for you, I mean. ❧

Galen Clark Recalls Sunrise in the High Sierras

*An intimate friend asked, "Galen, you are a good observer of Nature and
have studied the clouds up here for many years, what is your prediction of the
coming weather?" He quietly replied: "Ask the new arrival, the fellow that just
came here yesterday. He knows more about it than I do."*
　　　　　　　　　　—from *The Call of Gold* by Newell D. Chamberlain (1936)

I've not come on the good works of last year
but lived so long under Sentinel Dome its shadow

seems more the sweep of my own hand.
Ask someone who's coiled our new roads

in his mind, whose heart is warm
as a carriage house. He knows better than I do.

Pack bacon spent, the bivouac's deer down
to a shoulder, what would you guess remains?

In truth, my memory shifts like smoke
escaping a flue. Say I know the valley

better than myself. Who could choose?
And nothing stays where it's supposed to.

Stone in the roads becomes a powder, the Merced
overflows. I would walk atop moraine for days

never touching dirt. Now it's broken, rolls away.
How long then to turn the weedy mind?

Even the falls follow the wind. Here I stoop
to touch my cheek on the fresh-faced golf green

though it's been finished a full season. So
ask someone carried in with the stew bones;

he keeps faith with the Nation's steady time
where I had a dozen dawns just yesterday.

Ballast Water

stops ships listing,
riding too high
when empty of cargo—

each small sea
carries invertebrates, eggs,
algae across oceans.

The docked boat rises
as, from the hold, tropical
is jettisoned into temperate.

Surveying fauna
of Southampton Water,
the biologist

lists,
her notebook fills
with species—

Mitten Crab, Round Goby,
Zebra Mussel, Comb Jelly,
Seastar, Slipper Limpet.

Given weight,
they no longer float
like motes in an empty room.

Big Green | Bathsheba Veghte
Oil on aluminum, 24 x 13 in., 2016

JANE LOVELL

La Sélune

She winds her serpent heart through
Ducey and beyond
past herons motionless in fields,
the dreary marshes of the Baie, its mist
and reen and fern;

carries in her grume the squirl of eel
and salmon, fogbound boom of bittern;

deeper still, the dislocated bones
of laggy boys, onetime farm boys
wielding leaden swords but finding
only cloud,

mudborn fighters felled by raiders
cresting distant hills,
drawing the horizon to a knot.

Such short days, the churned-up mud,
the taste of it.

Now deep in silt, below her surface
of knapped flint they lie, safe
from lamp-eyed eels, the skilly current.

Beyond the farms, she barrels to the coast,
races swifts into the estuary,
floods pilgrim paths that wind across the sand,

charges clouds of saltbloom,
foaming sea-scrawl hauled in on the rush
of winter tides.

Earth exhales, the sky rolls in
and there's a moment built from water, an instant
when there's nothing but the glide and switch
of tern, lit and lost,
and lit again, above the sound.

ANNE BERGERON

Waterside | NONFICTION

I SIT ON THE BEACH at Colchester Point and look west across the wide expanse of Lake Champlain where the Adirondacks gather thick storm clouds to their summits. I scoop dry sand flecked with bits of white clamshell into my hands, then open my palms to the sky, letting sand and shell slip through my fingers. What I sift through feels old, the same sand that I poured from palm to palm as a child, the same remnants of shale and limestone scoured by melting glaciers thousands of years ago. It is the last day of August and a month of rain has the lake brimming. From the southwest a burst of wind hits my face, scattering my hair in tangles.

Most of the storms that roll onto this shore sweep across the lake from the southwest, ushered in by the Adirondack peaks on the lake's far side. Sometimes, storm clouds march steadily across the lake, imposing as skyscrapers. Other times, gray curtains of cloud skim the water's surface and the lake becomes a mirage.

When I was growing up in Burlington, Vermont, this ever-changing view of the lake and mountains was my constant companion, readily visible from any of my vantage points in the city—bedroom window, middle school classroom, neighborhood playground. But it was on the beach at my grandmother's camp at Colchester Point where I felt most at home. All I had to do was hop down a set of iron stairs and run along a narrow pathway to the beach, where an expanse of water, sky, and mountain invited me in.

For many of us who live on Lake Champlain's shoreline, the stories we tell about ourselves become stories of this particular expanse of water. So much of my family's conversation focuses on the deep orange of the sunset sky, the icy wind gusting off the lake, or the sapphire sparkles rippling the lake's surface on a sunny day. While we appear to be discussing the weather or the scenery when we revel in the evening sky or bemoan the cold or exalt the shimmering water, what we are really talking about is ourselves—how we acknowledge both beauty and harshness, and how we know that simply looking at an expanse of blue can soften any pain.

"This lake is in our bones," my grandmother used to say. As I child, I never knew exactly what she meant, but as I sit here today, sand sifting through my fingers, cool water rinsing my toes, I feel how this place inhabits me. Memories ease in on the wind, animating the liminal places between reality and dream.

Many of my fondest memories feature my grandmother and my father, the two people who most loved this shoreline. For my grandmother, the camp was her place to relax—she fished, rowed, swam, combed the beach for fossils, and grew sweet tomatoes, usually with me by her side. My father, conversely, saw her camp as something to improve, and tending to this place became his lifelong labor of love. He nurtured vibrant perennial gardens, added modern updates to our dwelling, shored up eroding embankments, and built epic fires in the never-ending process of beach cleanup, always trying to enlist me and my brothers to work with him. I preferred fishing at dawn and combing the beach in the late afternoon with my grandmother to shoveling stones and stacking driftwood with my father.

Since the deaths of my grandmother and father over a decade ago, our camp is now rarely used, and my family is making plans to sell it. I make more visits now. I walk the beach, dream of myself as a child. I stand at a threshold.

⬦

My grandmother taught me to pierce the flesh of a juicy worm onto a metal hook and drop my handline over the edge of the aluminum rowboat into the depths of nothingness and wait. When I caught my first fish, I tiptoed with her up the three wooden steps behind the pharmacy counter where my grandfather worked and nearly burst as I waited for him to pour pills onto clean white marble, count them with several sweeps of a metal scraper, then herd them toward amber cylinders. In one shaking hand, I held my fish

by the tail, a tiny yellow perch whose silver scales gleamed under fluorescent lighting. In the other, I gripped my wooden handline, wound with waxed string and dangling a row of tiny lead sinkers neatly stacked above a barbed hook.

In the rowboat, my grandmother had lifted her black-rimmed cat-eye glasses, parked them on top of the plaid kerchief that held back her brown curls, carefully examined my perch, and smiled at me.

"That," she said, "will be one to remember."

When my grandfather looked up from his work, his eyes danced with pride.

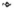

My grandmother read the lake by ciphering the waves, how they rolled, lifted, and broke, how wind tousled and stirred them to change. She was well aware that a lightning storm never really kicked up out of nowhere. There were signs to be read: moisture in the breeze, a flip of poplar leaves, an almost imperceptible line of gray stretched across the Adirondacks.

From the beach, she watched my grandfather pull the cord on the 15 horsepower Evinrude, white caps foaming as the boat bounced in the thickening waves. As we waited out the storm, my grandmother drummed her fingertips on the Formica tabletop in the camp kitchen.

"Let's go," she said sharply when the rain stopped. I followed her out to the patio behind the camp.

She lay a set of knives on the metal table.

"You're going to clean our fish."

And so my grandmother taught me how to clean yellow perch.

I had long dreamed of handling those knives. My grandmother kept them sequestered high on a closet shelf—blonde wood-handled knives with curved silver blades and sharp points. I had watched her clean and filet fish many times, but had never held the knives in my hands. She handed one to me, and when I felt the smooth wood cool the center of my palm, the trembling in my belly stopped.

"Follow everything that I do," she told me. "And do it slowly."

The dark green stripes of the perch glistened as they lay on their sides in the large metal bucket. Single black eyes stared up at me. I submerged my free hand and grasped a fish between my thumb and forefinger.

As if stroking a cat, I smoothed back the sharp dorsal fin and firmly clamped down on the gills.

I drew the knife too lightly through the center of the belly, leaving a jagged line. I slid the knife under the gills, sliced off the head, and dropped it into the metal pail. Then I parted the belly and my grandmother took the hose and ran a stream of water over the fish, exposing a glistening heart, liver, and intestines. I scooped cold entrails onto the table, and she rinsed a stream of blood from the white metal table.

I had seen my grandmother and grandfather clean many fish, and so the blood and scales on my hands, the feel of organs sliding through my fingers, and the bucket of heads felt familiar, right. This was the necessary preliminary to a lunch of fried perch or a dinner of my grandmother's tomato fish chowder.

I looked up at my grandmother for approval.

"Turn the fish over," she said, "and run your knife along either side of the backbone."

We continued on as the wind and waves began to settle.

Steam fogged the windows of the camp that evening as my grandmother stirred the perch chowder mixed with fresh tomatoes, potatoes, and sweet corn. The screen door on the porch creaked open and we heard my grandfather whistling Soussa's "Stars and Stripes Forever," his signature entry. My grandmother banged her wooden stirring spoon on the stovetop and stared straight ahead at the wall. Then she turned her head and lifted an eyebrow at me.

Over hot soup, my grandfather told us how he had made it to an island to wait out the storm, and how later, the anchor had held him as he pulled and pulled at the cord and the motor refused to start. In a headwind, he had rowed the several miles back to our beach.

"And, now," he said, "I'm tired."

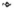

My grandmother once told me she wanted to braid my hair on my wedding day. I held the image close, like a promise, as I slipped into my simple silk dress in a tiny cottage a few feet away from the lake. I could hear our guests beginning to convene. Storm clouds had been building all day, a wind was gusting, and I knew we would have a storm.

My future mother-in-law came into the cabin and rushed me along.

"Quickly, dear," she said to me, "Before it starts to rain."

I left my hair loose and slipped into the white sandals Glynn had bought for me at a thrift shop three days earlier. They fit like Cinderella's slipper. During the ceremony, our fathers read poems and blessings as the steady wind wrapped around us like a blanket. As we finished our vows, tiny raindrops began to fall, and as our guests followed us toward the white reception tent pitched on the edge of the lake, the sky opened and rain poured down. We ran toward shelter and I imagined the wind was my grandmother's fingers, combing through my wet hair.

❧

It is the middle of January, and I walk with Glynn over thick shards of anchor ice on the shoreline. The temperature hovers near zero. A strong gale pushes black churning waves against the huge chunks of ice that look like shipwrecks. A bit of snow on top gives us traction and invites us to climb and explore. Frigid spray pricks our faces. Like prospectors, Glynn and I walk slowly in the subzero wind chill, examining the ice's thickness and its opaque glass veneer. It is full of dizzying cracks and reflections of the burning sky.

My father is dying, and we have left his hospital room to walk the winter beach and watch the sun go down. Tonight the winter sky explodes in long smooth bands of red. If it could speak, it would roar. We shake with cold, but cannot leave the winter shore and blazing sky until it is completely dark. Above the Adirondacks, a thin scarlet line of light seems determined to persist all night, or maybe forever.

Back in the intensive care unit on the hospital's fifth floor, we find my father asleep amid a beeping array of flashing screens. On a tray by his bed, a Dixie cup holds a tiny pink lake of melted strawberry ice cream, and next to it sits a flat wooden spoon. We stay for a while with him, and when I look out the window, I see that the ruby line of sunlight has vanished. I was with my grandmother when she died a few years earlier in a room on the same floor of this hospital, with the same view of the lake and mountains through her window. The expanse of the lake and the clear ridgelines comfort me.

My father dies the next day as snow falls hard. On a clear morning the next week, we stand by his grave in Lake View Cemetery, not far from my grandmother's headstone. From his burial site, I can see the clean mirror of ice glazing the distance to the Adirondacks. The space and silence of the view soften my sadness. ❧

The Fisherchild

for Faustino

One hundred years ago,
my great-grandfather
came home from fishing
and found his father and his mother
murdered,
his sisters raped.

He was a child,
a Mexican fisherchild.

I would not exist
were it not for the fisherly
whims of children.

To escape *los bandidos*
that killed and raped families
while children fished,
the fisherchild traced a sunworn
path to America,

where he met Ama Rosa,
where they had Ofelia,
where my grandfather courted Ofelia
—though her mother guarded the porch
with a shotgun—

where they had Maria Elena,
who would one day meet my father
at the long-gone nursery
on Florida Mango Avenue.

I would not be here
were it not for a sunworn path
from Mexico to Texas.

Let this path open ever wider
for the fisherchildren to stride in.

Let them arrive
with their fishing rods
on their shoulders,
so when they come home,
arms full of trout,
they will find the round smile of Papá,
the long braids of their sisters,
and the warm voice of Mami,
telling an almost-lost fairy tale
starring a brave,
brown
fisherchild.

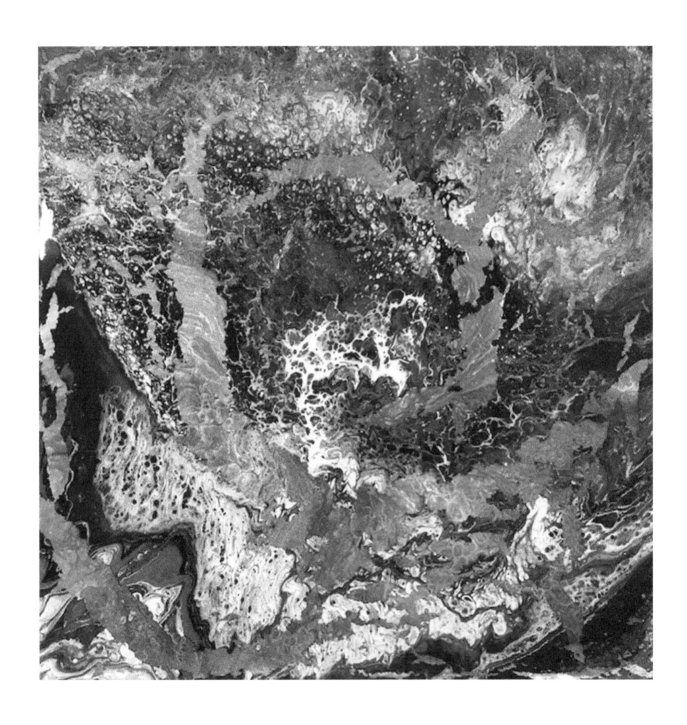

Archipelago | Sᴀɴᴅʏ Cᴏᴏᴍᴇʀ
Acrylic pour painting on wood panel, 18 x 18 in., 2018

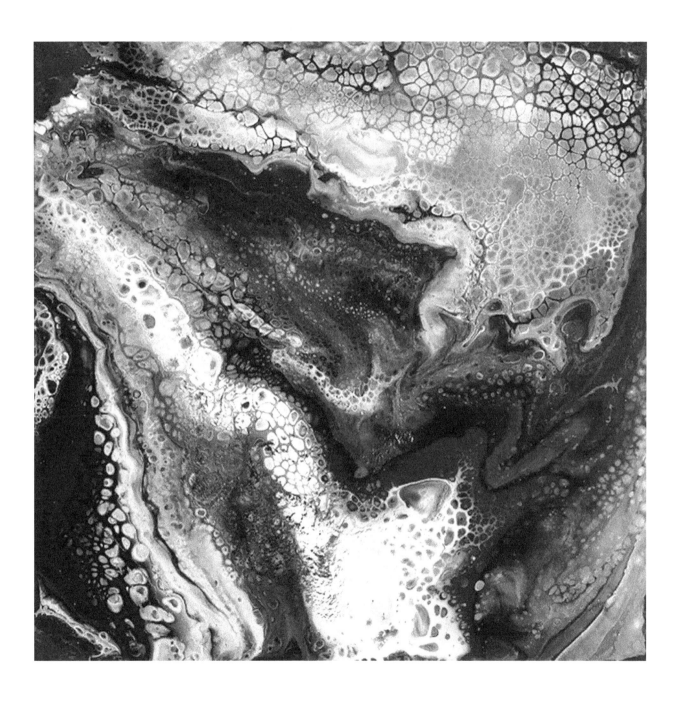

Hemisphere | SANDY COOMER
Acrylic pour painting on wood panel, 18 x 18 in., 2018

Lake Superior | SANDY COOMER
Acrylic pour painting on wood panel, 8 x 10 in., 2018

Pebble Beach | SANDY COOMER
Acrylic pour painting on wood panel, 9 x 12 in., 2018

Whose Words These Are | NONFICTION

Andrews Experimental Forest, Oregon

DECADENCE

I stretch my arms around the trunk of an ancient Douglas-fir—its name hyphenated because it is not, according to botanists, a true fir tree, but occupies a genus of its own. One hugging reach over coarse bark, then starting again where my far finger touched, and then again: three times and I have yet to complete the circle.

Eighty years is considered mature for a Douglas-fir, the best time to turn it into lumber. This ancient tree is hundreds of years past when it could have usefully contributed board feet to the construction trade, to the bones of multiple American homes. It has spent much of its life in slow growth and is likely rotting at its heart.

The old foresters—the timber cutters—called a forest of such trees decadent. Even younger trees they've called senescent—past maturity, past their prime, as good as dead.

I'm thinking how captivated I was, as a child in New Hampshire, when my family hiked through a section of virgin forest in the White Mountains. I remember, still, the quiet disorder of it, needled branches against sky, the sense of parting a wilderness untouched by anyone before me, where bears and mountain lions surely hunkered in the shadows. Later I learned of the climax forest, as though there was such a thing as a peak a forest could reach, a point of stability. As a conservationist, I embraced the term old-growth, without knowing that it first came from the logging industry to denote old trees that needed to be cut; in my time, it meant what had survived logging and needed protection. Old-growth, I understood, was essential for wildlife habitat, for biodiversity and water quality, for its wildness. And now, we've arrived at ancient forest. "Ancient" confers value in more than economic terms; "ancient" is venerable.

"Decadent," though, stops me in my forest-litter tracks. From the Latin *de*, apart or down, and *cadere*, to fall. Can we not reserve this for certain humans and their behaviors? My dictionary tells me: *having low morals and a great love of pleasure, money, fame, etc.* Synonyms: corrupt, immoral, degenerate, debased, debauched, self-indulgent. Trees may age, they may fall down; if they have character, it is built on height and solidity, and on their community spirit. Alive or dead, they are the opposite of decadent as we understand its meaning.

Words are among the songs we hear, the sounds carried even into forest. I commit to an October listening: to the plinks of raindrops on leaves, the calls of birds, water running over rocks, the names we give in reverence and dismissal, the past as it informs the present.

COOKIE

At the site where researchers are engaged in a long-term study of the decomposition process of various species of trees, five-and-a-half-meter lengths of logs have been laid out now for thirty-two years. They are moss-covered, bark-loosened, insect- and fungi-harboring study subjects, marked with flagging, sliced apart, punctured with plastic tubing designed to capture gases and data. I walk among them while listening to the raucous calls of ravens, then the startlingly loud wingbeats as one weaves past me through the living trees.

Next to the path lies a plastic-wrapped cookie. A tree cookie is what it's called—a cross-section of a tree showing its growth rings. In this case, it's a round of wood about three inches thick, cut from one of the logs at the study side. It apparently awaits someone to haul it off to a lab, where its rot and the life wrapped within it will be catalogued and analyzed. This cookie is bound in clear plastic cellophane, many layers around and around its bark and then more to secure it in the middle of a piece of plywood. A paper under the plastic must hold all its necessary identification, but I can't read it through the needles and leaves and green algae that have gathered on the plastic. This is not a freshly prepared cookie, but may have been awaiting its transport for some time.

I know, though, the word-tasty parts of a cookie, outside in: bark, cambium, phloem, xylem, heartwood. In my part of the world, in starvation times before the salmon returned, indigenous people survived on the cambium of cottonwood trees.

DOGHAIR

I force my way through this forest of young firs. The trees, the largest among them perhaps ten inches in diameter, are lined up in rows, four and six and more feet between them, but it's their low branches, so thickly sprouting from their sides, that block my way. They reach past one another, forming a stick wall, leaving no space for a wandering human to pass. I stumble through as best I can, pushing at branches, trying to avoid the thick vines and thorns of the Himalayan blackberry, an invasive that takes over disturbed areas. I'm as protected as I can be, in my rainsuit, from the rain that looked like it might quit but did not, and from the scratchy branches and blood-drawing brambles.

I'm thinking "doghair," a term I learned back home in Alaska when accompanying an ecologist through birch forest that had grown up, even-aged and tightly packed, after a fire. Doghair birches, Ed called them, and I thought he was naming a species I'd never heard of. But no, "doghair" meant the forest was as thick as hair on a coarse-furred dog, a terrier perhaps. We twisted and turned to slide between and among the narrow trunks and their shoots.

This hillside, on private land just outside the national forest, is another doghair forest, nearly impenetrable. It's what's known in the logging business as a plantation forest. After the area was clear-cut fourteen years ago, it was first burned and then most likely treated with herbicides to keep out the weedy plants that would normally be first to recolonize it. Douglas-fir seedlings were planted in rows. Now the new generation of trees has grown to thirty feet in height, dense enough to intertwine their branches and block most light from reaching the ground. Loggers may come one day to thin the trees, so that those remaining will have room to grow until economics encourage another clearcutting. Or, if the trees are left on their own, natural thinning (competition mortality) will occur, as it does in any forest regrown after a major disturbance. These trees are already competing for sun, water, and nutrients. Some are thin enough

to circle with my hands, and there are gaps where the weakest may have been crowded out early on.

I stop in a cul-de-sac of blocking branches. The ground at my feet is carpeted with dead fir needles and the dry brown stalks and leaves of ferns, with blackberry vines twisting through. I spot some tiny orange mushrooms in this otherwise monochromatic landscape, this barren bottom.

I push my way in another direction, past charred logs and old stumps overgrown with moss. Jays are calling from higher on the hill, and now a smaller bird, close in, is chipping. I *pssst* to it, and it comes in closer, hopping among the low branches, eyeing me curiously. *Chip, chip, chip-chip.* It's a Pacific wren, known to associate with old-growth forests. In this case, it seems quite happy among the tangle of branches. It must be finding something that it needs here—shelter, food, less competition from other birds. We make our noises at one another until a second wren joins us, and then they both fly off.

NEWT

Rough-skinned newts are out after rain, crossing trails. They twist their whole bodies into sinuous curves as they step their right feet forward, then their left feet, and their right again. With each step they turn their feet out and over, flashing their orange soles. Long tails curl behind them.

One on the road seems lethargic, as though stunned by a passing car or a predator that dropped it. I stoop to study its wet brown back, its yellow slits of eyes, its outstretched feet that look like baseball mitts. I trail a finger along its back, testing its roughness. Not like sandpaper, but not slick either. I've expected my touch to send the newt scurrying or into its defensive posture of arched head and tail, warning of its toxicity by showing its orange underside. When it doesn't react, I pick it up to examine its underside for myself. It's soft and light in my hand, like a rubber toy, and its orange is as bright as the fruit. When I set it down again, at the side of the road, its throat pulses.

I wipe off my hands on wet ferns, just in case. Curious scientists have determined that the neurotoxin in a single newt, when ingested, can kill 1,500 mice. In 1979, an Oregon man reportedly ate a newt on a dare—and died within hours.

Farther down the road, I find a newt that clearly had a vehicular incident. Flipped onto its back and

partly flattened, it lies with one elegant front foot held over its belly, as though trying to press out a stomachache. The books say that in spring, when newts leave the woods en masse for water bodies, their traffic deaths lead to local depletions. I smile when it occurs to me that the loss of all those newts would be a case of neutralizing newts.

Trap-Happy

The trap holds a sleepy chipmunk, curled up in her comfy, dry nest of organic cotton wool. She has eaten her fill of the trap bait—the peanut butter, oat, sunflower seed, and molasses mixture that the researchers have provided—and settled in for a nap. When Tom holds her in his hand, the little glutton empties her cheek pouches, an oatfall cascading. Her metal ear-tag winks at us; she has been here, or in another trap, before—perhaps multiple times. There are so many chipmunks in the traps—so many repeat customers—that the crew no longer takes their data but only sends them on their way. Spotted owls are declining in the woods, and the biologists want to know everything about their lives. They know that the owls hunt by night while chipmunks are active during the day; chipmunks, thus, are not a significant prey species.

The clever chipmunks, though, have learned that the traps offer food and shelter, and whatever trauma they experience at being interrupted mid-nap by a human hand is not enough to deter them. The researchers call them trap-happy.

Disturbance, Natural

It's raining, still. It's been raining for days. Lookout Creek is higher than it was in the sunny days when I first arrived, but far from flood stage. Floods come later, when rains fall on the higher snowpack and the rain and snowmelt wash together down the hillsides.

In 1996 the last big flood rushed through here, undercutting the bank across the way and leaving rocks—some as big as armchairs—piled in berms on my side and especially in a large logjam in the creek itself. Douglas-fir giants, undermined by floodwaters, fell from this side, and more trees, branches, sticks, slabs of bark, all manner of vegetative matter washed against them, turning the current away from the old, shallow channel near this bank to the mad torrent that is now the main channel. This side of the logjam, among the rocks and slower water, sediment has grad-

ually been filling in, and the higher ground is home now to a huge variety of streamside plants—among them alders, willows, vine maples, and lush islands of the big-leafed coltsfoot.

As destructive as floods can be, the periodic restructuring of a stream's curves and straightaways and the redistribution of cobbles and wood is an ecological process with benefits to the system. Stream edges open to sunlight and new growth—including the nitrogen-fixing alder. Logjams and boulder piles slow the current and provide shelter for fish and other aquatic life.

But I have to ask: just how "natural" are natural disturbances in our time? Fire, insect infestations, changes in weather patterns due to climate change—we humans have a hand in all these. In the case right here, clearcut logging in the watershed and the construction of logging roads close to the creek, in the 1950s and '60s, affected the absorption and run-off of rain and melting snow. The flood of 1996 was more severe than it might have been in an intact landscape. Absent logging, might that spindly tree tottering on the edge be standing strong within the forest? Might that eroding bank have held back more soil, more roots, more vegetation? Might fewer fish and their eggs have been swept away? Who's to say? There's no control group for these large-scale experiments.

Disturbance, Human-Caused

I walk the final spur road, not wanting to abuse my rental car. It ends at a wide clearing, a landing area for logging that took place in 2002. From there the land drops into another drainage, and I'm looking through scattered tall trees and scrubby brush towards the Blue River and more distant mountains. I'm facing not a clearcut, but a cutting unit, in which a more modern forestry approach was utilized. In this system, some semblance of what might have happened in a more natural disturbance is maintained.

Hence the standing live trees, and the standing dead ones—snags. Under the plan, nearly half of the trees in the unit were left. The next year, the area was burned to reduce slash—the limbs and tops left from logging—and to retain the role of fire in the landscape. Perhaps a third of the live trees were killed by that fire, creating snags that provide homes for birds, squirrels, and other organisms. Then the area was planted with several species of seedlings.

I poke around at the edge of the clearing. I don't know all the plants here, but they include small pines and cedars, ferns, a viney groundcover, thistles, and dandelions—weedy species all. Grasshoppers leap and crackle. The terrain falls sharply at the edge, but I can see that some of the standing trees and snags are blackened on their sides, fire-scarred.

People—hunters, I assume—have camped here, in the clearing. There's a fire pit of broken rocks, with partially burned logs in its center and some additional split wood lying to one side. And trash: a crumpled paper drink cup, a plastic drink bottle with an orange cap, many bits and pieces of plastic, a faded green gallon jug of motor oil still mostly full.

LITTER

I make my slow way along the three-mile trail, looking at tall trees, tiny mushrooms, and the way light filters through leaves and needles. On the entire traverse, I find a single piece of litter—the bright blue shiny-paper corner of a nut package, saw-toothed on its top edge, torn to a point, with a picture of an almond. The entire scrap is no larger than a nickel.

There is litter, and then there is litter. The human litter, unnatural in its color and shape, catches my eye. It belongs to trash, garbage, refuse, waste. The forest's own litter—its dead leaves, needles, bark, cones, seeds, stems, twigs, and branches—is everywhere, layer upon layer of dropped and fallen organic materials. In one year, on one acre, forest litter will add up to five tons. This litter is food for bacteria, fungi, earthworms, insect larvae, and other decomposers.

Far off, a woodpecker hammers on a tree, raining down more litter to the forest floor. Right there, beside the trail, a millipede is snacking on a piece of *Lobaria*, the lichen otherwise known as lungwort. The scrap has fallen from the forest canopy, where it has captured nitrogen from the air. I look the millipede up later to learn that it's *Harpaphe haydeniana*, more commonly known as the yellow-spotted millipede or the almond-scented millipede. The yellow-tipped sections situated between its black back and its many legs are said to warn predators of its toxins.

Almond package part, meet almond-scented creature. The first has no smell, the second I fail to check.

YEW

I have never seen trees so consistently engulfed in moss. The one I'm standing by, deep in the forest, has no needles at all on its lower branches, no foliage until about twenty feet up. Instead, its dead branches drip with moss, looking like loads of tinsel on a Christmas tree. When I look closely at the strands and the dead wood beneath them, I discover another miniature forest of molds, lichens, and fungi, including tiny white mushrooms. Raindrops bead at the ends of moss strands, more silver for the tinsel, and maple leaves catch here and there like ornaments.

The tree's bark, mostly covered with moss, is clear enough in a few places to see its thin brown scaliness over a smooth redness. It's this bark that made the Pacific yew famous. The drug Taxol was first derived from it in the 1960s, for the treatment of breast and ovarian cancers. It was feared for some time that the slow-growing and never abundant tree that lives under the canopies of old-growth forests would be overharvested for that purpose. Today, though, Taxol is synthesized from a European yew as the most commonly prescribed cancer drug.

The yew tree is said to represent both death and immortality. Death because its red berries are poisonous, and immortality because of its long life.

I place my hand on a patch of exposed bark, cool to the touch.

CONK

These woody fungi are everywhere in the forest, growing on the sides of rotting trees and fallen logs. I squat beside the trail to look up at the white surface of one underbelly. It's smooth, like the skin of a beluga whale, a sharp contrast to its toughened dark top littered with dead needles. The pores are small, again like skin. Inside the pores, invisible to me: spores.

Shelf fungus, bracket fungus: these are the general names for a variety of fungi—probably more than five hundred species—that feed on dead wood. While the fungus, with its network of fine filaments, rots the inside of the tree, attacking the tree's cells, the conk serves as its fruit.

Conk is an American word of uncertain origin, perhaps from *conch*, a shell. The resemblance is fanciful, although I can imagine someone walking from beach into forest, bringing a familiar image to what she finds there, lined out on bark as shells on sand.

My friend Eva, when she was dying of cancer, used to stop on her walks through the woods near her

home to scratch into the hidden soft spaces of conks the word *hope*. Every conk in this forest, a thousand miles from Eva's living conks and her ashes, reminds me of her—both her passion for life and her acceptance of death as part of ever-moving, ever-changing, ever-cycling life. As a scientist and a poet, she appreciated conks not just for their plain beauty but for their role in wood decay, for returning nutrients from dead wood back into the forest ecosystem.

Eva wrote on the last page of her last book, "We died and the earth continued and changed. And so, living, dying, dead, reborn in other forms—did we."

WINDTHROW

On my last day's hike, my trail is blocked by a fallen fir, its trunk laid down over shattered limbs. What winter winds can knock such giant trees off their feet? What pull of gravity, of slow-moving slide of land, fells them? What illness or weakness leads not to bend but topple?

This one's root wad is a mess of gnarly roots, clumps of earth, entwined rocks. Compared to the tree's height, the roots seem shallow, but I know their thinner fibers, here torn and hanging, dig deeper and wider. It's said that the mass of a tree's roots roughly equals the mass of a tree's crown, one a sort of mirror of the other, above and below ground. But between those two mirrors may be 250 feet of trunk, and all that height is anchored by roots that lie mostly within the top five feet of soil.

Windthrown trees turn up mineral soil to feed new vegetation. Their root wads provide hiding spaces for all manners of creatures—from spiders to bobcats or bears. If I were caught in the forest overnight, I'd choose one (absent a bobcat or bear) to shelter under.

Here it begins again: the downed tree, the rot, the fungus and the moss and the bark shed to litter, the slug and the vole, the violet in spring, the endless circle of life. I can't help but think of John Muir, lover of both forests and words. "Nature is ever at work building and pulling down, creating and destroying, keeping everything whirling and flowing, allowing no rest but in rhythmical motion, chasing everything in endless song out of one beautiful form into another."

There's no last word, only the chorus of it all. ❧

Offering #2 | Linda Laino
Watercolor on rice paper and panel, 12 x 10 in., 2015

Nest │ Linda Laino
Watercolor, mixed media on hand-felted wool and rice paper on wood panel,
12 x 10 in., 2017

Gem

It's not a dwelling they're building,
he said, about the bowers of the bower
birds. They scavenge the best detritus,
whatever gems they can find—
a leaf, a berry, a shell, a feather,
bits of plastic or broken glass—
in monochromatic hues, and then
in an array of cerulean or tangerine
or russet or bone or black,
they build their temples to longing.
It's not a dwelling at all, he said.
It's like a poem waiting to be read.

Loomings | Brit Barnhouse
Ink on paper, 6 x 10 in., 2018

NATALIE TOMLIN

An Untestable Question | NONFICTION

ONE BOOK PRIED A WHALE'S MOUTH OPEN WIDE, sawed the pale curve of jaw, gum, and rigid plate in half so I could learn all about the baleen: ragged hair flattened under the flush of a bucket. Afterward, crumbs of krill wriggled in a soused mustache.

There was another book I was never able to find. I can't recall much, except miles of wrinkled gray skin wreathed in barnacles, blue-green foam, and a jagged flap for a mouth. The pages were damp and I pressed and flattened near the spine so the whale could grow even longer.

The most popular part of the exhibit invited children to crawl inside a heart. I made the mistake of going in after them, my knees screaming out against the hard plastic until I eventually shared the chamber with my child and two strange toddlers. They were lucky enough to be able to stand or sit on a conveniently located flesh-colored bench. I squatted while we all took in what we had come for: a backlit transparency that placed a whale side by side with a jet, a football field, a series of cars.

Bālaena, phalaina—both mean "whale," the being and its sieve, mind, and attention. Facebook deactivated, Google alerts on climate change created, filters woven. Cope by narrowing slats to dim the room, sitting tall, catching only the most delicate morsels inside each breath.

Subtitled interviews with indigenous people played on one side of the exhibit, but I didn't have time to watch. I went home and read about people who revered whales precisely because they are unknown, because they spend ninety percent of their lives underwater. On Wikipedia, I learned that the Japanese buried whale fetuses with headstones. On YouTube, an oceanographer introduced a whale who had been hit by a boat and was later discovered to be pregnant.

Because I loved whales as a child and was born in a baby blue bedroom that felt like the bottom of the sea, I chose whales as my firstborn son's theme. I registered for a whale comforter at Target and my husband cut a mother and baby from construction paper for home-made shower invitations. Later, on a July afternoon, I sat sweating and huge, surrounded by a pod of family exclaiming over burp cloths and swaddle blankets covered in whales.

Then, even before my son came, they were suddenly everywhere: studding J.Crew chinos like polka dots, embroidered on throw pillows, dangling from gold chains. My husband, ever the philosopher, stood silent up until this point, but couldn't help himself as he faced the whale images printed on our thank-you cards: *What whale looks like this?*

To think that I had imagined a mammal completely still and alone with its door ajar, water gushing in and down, a basement flooding. It must have been Disney or some other cartoon, but I had assumed that they ate by chance, through sheer volume, the way I could strain a few minnows out of a dozen or so metal buckets of lake water.

Then, the day after the March for Science, suction-cupped cameras determined that whales scout krill-dense waters at night, plunge with mouths open, linger in large groups. That same day, visiting the museum, I lifted my child to touch the button that plays a recording of their calls. I paraphrased a placard that attempts to translate what they are singing, what they are repeating. Could it be they are making their own music? Ecologist Thomas Eisner calls this "an untestable question." ⟶

Jupiter and the Milky Way | PATRICK ZEPHYR
Digital photography, 2017

JOE JIMÉNEZ

And what if I'm not more than any of this?

Once, I saw a great gar tear apart a gull.
Yes, my abuelo bottled his fat knuckles
about my neck,
my boythin chin—
 said, "Look."

The sound sun makes when it rises can be heard
if I listen with brown skin I no longer speak,
which is a flare gun,

 a codex spared by God.

After, the gull wing floated in the dark river.
A little sailboat.

 A little smoke.
 A sigh doped-up with patience, dropped
from the sky.

All day, I can reach for that gull.
All year. It won't mean
I want to leave the river behind.

It won't mean I can't kneel for fruits that kiss earth.
Offer them to satisfy order, to defy.

Most days, I don't mind
laying my blown boybones down in the mud
on the shore
near the sedge
 under sun.

I only hope I keep enough good teeth.
I just hope someone, somewhere
remembers

shadows also deserve to eat.

Genesis According to Stone

Lo, the poor Indian! whose untutor'd mind
Sees God in clouds, or hears him in the wind;
—Alexander Pope, 1733

In the beginning was fire
and rock forged of stars, glittering with furious

memory of the womb that expelled it. Articulate
stone dissolved to liquid, seeping ochre,

cyan, rust from black crystal veins.
And the earth was formed and life emerged

and it was good. But the ground buckled, cast
its glassy ash into the sky, pressing stem and stalk

into itself. The waters rose, layered themselves
over the slow-footed saurian, the hydra-headed snail.

At last the seas withdrew to their bounds,
trailing glyph of wave, white arc of shell

embedded in stepped stone walls.
At their feet, archaic volumes scattered,

their rock-pages open to the many-faced moon,
the traveling sun.

Finally, one who spoke stone arrived.
She recorded creation's gospel

without cipher or alphabet. Striking rock
to rock-face, she traced her testimony,

marveling at what she saw each day,
or perhaps just that once, when mist was

an untamed cloud come low, the valley of flowers
unclassified, simply wild with abandon.

Fire Behavior | Judith Skillman
Oil on canvas, 14 x 11 in., 2018

AMY WELDON

The Serpent | FICTION

Genesis / Proverbs 31

HE LEFT HER ALONE in what used to be their garden, with blackberry brambles clotting the fencerows and all the animals bawling to be fed. All winter he'd drunk and raged and watched her. She'd spent whole days hunkered there next to his sleeping couch, her hand limp in his fists. The jars on the pantry shelves and the smokehouse hams diminished: three, then two, then one. When February dawned, bright and cold, he wobbled away down the red dirt road with his knapsack on his back, his clay-colored hair bristling. *You'll never survive here without me,* he shouted back at her. *Every move you make will be in pain.* Never, once, could she have dreamed that she'd be glad to see him go. But left alone, she could put the garden back the way it was.

So she took stock. The tin roof on the house: still good. The well still drew; the fig tree and the plum and peach trees were setting bloom and leaf. The vegetable patch, however, had that sunken, scraggly look a garden gets when a woman has her mind on something else. Rickety wooden winter-bleached tomato frames still cradled brittle white vines, where a few cold-leathered orange fruits still clung. Blue-gray collards burst up into yellow flower. Pepper plants were smashed flat where some creature had rummaged through. A possum had laid waste one last melon over by the fence, its striped hull cracked and teeth-raked, its faded heart laid bare. At least the deer fence, ten feet high, was still intact. The metal discs he had cut to scare them still shimmered and bounced in the wind. An evil little face was etched into each one; they'd done that together, laughing, charming a protection for their food against the crows and deer and dangers threatening this garden that would surely feed them both together for all time.

Without him, the milk cow lost a tendency to kick. The chickens clustered back around the house. The big yellow cat came out from under the porch. She replanted the seeds, upright in their twists of brown paper. *Ole Timey Blue. Cow Horn. Cherokee Purple. Trail of Tears. Arkansas Traveler. Mortgage Lifter. Hill*

Country Red. Yellow Gold. Moon and Stars. She ripped out the old tomato vines and the tall fierce weeds and hauled them to the place where the other garden skeletons were melting down to next year's food. She stropped the razor and sharpened the scythe and swung it through the high grass to cut it all around the house, the garden, the fig tree. Because in the warm weather coming on, snakes would be moving.

He had hated snakes beyond reason, ever since he opened the chicken coop and found a brown-and-gold rat snake stretching its mouth open around a fresh white egg. *Don't bother them and they won't bother you,* she'd argued. *They keep the mice away.* She'd stopped up every hole in the coop and reburied the fence wire and thought that was the end of it. But in his bad time, as the grass feathered high and the garden grew wild and then withered and the chickens got feral and experienced, she came to fear what might be out there: the panicked muscle writhing to life under her foot, the hot needle to her calf. Overgrown and wild and forlorn, this was not the happy garden they'd been given anymore. She'd die out here, no one to bury or to mourn her.

But now, on a summer morning, the first tomato-ripening heat just taking hold, she lets herself release those fears. The garden is hers again. The seeds are up and flourishing. The melon-hills are crowned with glory, the beans climbing their cornstalks right on time. Green baby crabgrass bristles between the new collards and the lettuces. If she lets crabgrass go, she's in for a war, gripping giant clumps of it and heaving it out. Gripping is a problem for her now. At night her hands ache, down in the joints. So big-knuckled and rough they are, so different from the slender fingers she held up before her own eyes as a girl, marveling *This is my body, all of this is me.* Deep in her hip is a grinding of bone on bone that freezes her in place, howling, if she catches it wrong. So she stretches and she takes a rest and she tries to ignore the way her body is no longer fully hers. Traitorous and tired, it's been swelled and split by both her sons. The one son's

dead. The other—she doesn't know where he is. It's a pain worse than her swollen hands to think on them. So she chooses the pain that feeds her. She rubs the pig fat against her joints at night to keep them as supple as they can be for the next day in the garden. For a woman, keeping herself fed in this world is a full-time job. And now there's only her, out here at the end of the world, to see to it.

She chops the young crabgrass with her hoe, turning the roots over to bake in the sun. Then something rustles in the squash vines, slow, low against the ground. She freezes. There's only one thing that sound can be. But she can't just back away or it'll find her sometime she's less ready for it, like when she's barefoot on the porch steps, walking out into the yard at night to see the stars. This is her garden. She has to be free to move in it.

She steps back and slams the hoe into the soil. *I tell you to come out.* The air thickens with a heavy liquid hush of skin on skin. She chops the dirt. *Come out.* Slowly a rattlesnake unfurls itself into the light. Black birdwing shapes on its back, bird after bird after bird, loop toward her in the dirt. Its thick midsection is as wide as her right arm. Its black tail ends in a long cluster of rattle-beads. Its head is as big as her own outstretched hand, fingertip to wrist. And its lidless eyes are open, watching her.

Cold fear shoots down her spine, locking her to the dirt. Words scramble in her head: *be still, it'll strike, oh why oh why did—* She stares at the flat spade-shaped head and marshals her lost man's counseling words: *big snake is less to be feared than a small one, big snake knows what to use his venom on, little snake's just like a shirttail boy, lash out at anything he can.* Wild shirttail boy. Lost son. So much fear and grief now all undone in her. Why, oh, why did she command this beast out into the light?

The black eyes watch her. *Snake venom takes away the joint pain.* Whose voice is this? *Sure it does.* Longing rises in her chest, coloring the fear like wine in water. No more pain. Dizzily she pictures it. Step forward. Grasp this rope of muscle around its throat. Slip her right hand underneath the belly scales—it will be heavy—and lift it toward her heart. The flat eyes stare through her at nothing. *I'll be still.* Where is that voice coming from? *You'll pick me up and I'll be quick. Just one little bite. You won't hardly feel it. And all your pain will then be gone.*

Inside a pure cold emptiness opens, waiting, humming like her lost sons in their sleep. It is the place from which fear reaches for her in the night. The space in which her thoughts chased around and around as her lost man gripped her hand between his own. It is not-knowing. It is intolerable. It is inescapable. It is where she must live now, on her own. She cannot run. And the doing and the caretaking of each day—the clothespins on the line, the sharp edge of the blade against the dirt, and the red skin of the fruit her own hands have brought forth—is the sturdy warm force that sends the fear back into its hole.

She lifts the blade and swings it down. The big snake bunches backward in a self-protective coil, rattle-buzz slicing the air. It's not a hiss, it's a harder sound, silver-edged and mean. Mean? Afraid. All down its neck is a split in the black-and-tan scales her blade has opened. It's bleeding. It is red meat and nerve and hunger, like any other thing.

She steps back and the rattlesnake whips away under the wide sunlit leaves. The fence quivers as it hits what must be a hidden hole, back there, in the wire. It's out in the pasture now, seedheads swaying as it passes. With her hoe upright in her hand, she stands and watches it. Rustle, rustle, away and out of sight. ❧

Yakima River, October | JUDITH SKILLMAN
Oil on canvas, 12 x 12 in., 2017

2035

For decades we searched ambient oases, pulsing body clouds, red giants,
blue dwarf glare, moons wet with methane seas. We mapped Earth's neighbors
to the millimeter—every hill gully hollow—to mark a landing site. We packed the ship,
checked the specs. Unfurled the solar sails and thrust out for our new world.

We ogled our moon in reverse, slept the route with exercise alarms, system
diagnostics, messages from home. Text only. We trusted them to watch
our small steps. Some of us learned to pray—for safe landing, for oxygen
pressure, for father sister sick cousin, for mission control. Something worked.

Each day we crumble clay like cat litter, blend minerals as instructed
while the nuclear electric reactor drips clicks in oxygen tanks, its regulated tick
like a leaky apartment faucet. We miss Earth annoyances now: traffic jams and
telemarketers and too-sweet iced tea as we wring water from the ice cap sip by sip,
catch the liquid before it freezes back. The reclaimer flushes it, we drink again. We tilt
the mirrors, calculate, adjust, raise a greenhouse, huddle in blow-up tents for soybeans to bud.

Brit Barnhouse's work can be found or is forthcoming in *Visitant*, *Door Is A Jar*, *The Wild Word*, *Writers Resist*, *Fugue*, and *Saltfront*. When not writing about the ever-blurred lines between animals and humans, she can be found giving her dogs belly rubs, tossing treats to the neighborhood crows, or hoping for close encounters with whales while paddleboarding in the Puget Sound.

Anne Bergeron is working on a collection of essays that explores rural living through the lens of our changing climate. She lives in an off-grid home of recycled materials that she and her husband built in West Corinth, Vermont. A 2011 recipient of a Rowland Foundation Fellowship for her transformative work in public education, Anne currently serves as the interim director of the Writing Center at The Sharon Academy.

Sebastian Bitticks holds MFAs in creative nonfiction from City University of Hong Kong and poetry from the School of the Art Institute of Chicago. He is a visiting assistant professor at Marquette University in Milwaukee. His website is sebastianbitticks.com.

Joanna Brichetto is a naturalist in Nashville, where she writes the urban nature blog *Look Around: Nearby Nature*. Her essays have appeared in *Hippocampus*, *storySouth*, *The Ilanot Review*, *About Place*, *Longleaf Review*, *Vine Leaves Literary Journal*, and *The Fourth River*.

Sandy Coomer is an artist and poet. She is the author of three poetry chapbooks, including *Rivers Within Us* (Unsolicited Press). Her art has been featured in local art shows and exhibits and has been published in *Lunch Ticket*, *Varnish*, *The Wire's Dream Magazine*, and *Inklette*, among others. She lives in Brentwood, Tennessee.

Alexis Doshas works with film using pinhole cameras made from tins, a 1950s model Rolleiflex, a Kodak Brownie, and a Hasselblad 501c. She also works with cyanotype and Van Dyke printing processes and archival inkjet prints from film and paper negatives. She works out of her home studio in southern Vermont. Her website is lexbealadoshas.com.

Mike Freeman lives in Rhode Island mostly as a full-time parent. He has written two books, including the outdoor memoir *Neither Mountain Nor River: Fathers, Sons, and an Unsettled Faith*.

Raquel Vasquez Gilliland is a poet and painter inspired by folklore, myth, and plants. Her work has been published in *Luna Luna*, *Fairy Tale Review*, and *Dark Mountain*. Her first collection of poetry, *Dirt and Honey*, was released in May 2018 by Green Writers Press.

Lauren Grabelle's photography falls in the matrix where fine art and documentary meet, where she can tell truths about our relationships to other people, animals, nature, and ourselves. Her work has been exhibited in galleries in London, New York City, Italy, and Montana, among other places, and has been published in *The New York Times*, *Harper's*, and *Virginia Quarterly Review*.

Amy Guidry lives in Lafayette, Louisiana. She received her bachelor's degree in visual arts from Loyola University of New Orleans. Her work has been exhibited in galleries and museums nationwide and is present in public and private collections throughout the United States, Canada, Europe, and Asia. Her paintings have been featured in publications such as *American Artist*, *Adbusters*, *American Art Collector*, *Hi-Fructose*, and *Huffington Post*.

Emily Alta Hockaday is a poet and editor living in Queens. Her chapbook, *Beach Vocabulary*, will be published by Red Bird Chapbooks later this year. She is author of three previous chapbooks: *Ophelia: A Botanist's Guide*, *What We Love & Will Not Give Up*, and *Starting a Life*. Her poetry can be found in literary journals including *North American Review*, *The Collapsar*, *Cosmonauts Avenue*, and *Newtown Literary*. Her website is emilyhockaday.com.

Joe Jiménez is the author of *The Possibilities of Mud* (Korima, 2014), *Bloodline* (Arte Público, 2016), and *Rattlesnake Allegory* (forthcoming from Red Hen Press). His essays and poems have appeared in *The Adroit Journal*, *Iron Horse Literary Review*, *RHINO*, *Aster(ix)*, and *Waxwing*. Jiménez was awarded a Lucas Artists Literary Artists Fellowship from 2017–2020. He lives in San Antonio and is a member of the Macondo Writing Workshops. His website is joejimenez.net.

Kateri Kosek's poetry and essays have appeared in *Orion, Creative Nonfiction, Catamaran,* and *Terrain.org.* She teaches college English and mentors in the MFA program at Western Connecticut State University, where she received her MFA. She has been a resident at the Kimmel Harding Nelson Center for the Arts in Nebraska. She lives in western Massachusetts and is working on a book of essays about birds.

Linda Laino is an artist, writer, and teacher. She has an MFA from Virginia Commonwealth University. Since 2012, she has resided in San Miguel de Allende, Mexico, where the surreal atmosphere and sensuous colors have wormed their way into her paintings. Her essays and poetry can be found in *Elephant Journal, The New Engagement, Sheila-Na-Gig Journal,* and *Life In 10 Minutes.* Her website is lindalaino.com.

Colette Lawlor's poems have been published in magazines and anthologies including *The Oklahoma Review, Aesthetica, Mslexia, Southlight,* and *Electric Acorn.* She received her MA in creative writing from Lancaster University in 2009, and her writing incorporates her interests in biology and landscape. She lives overlooking Morecambe Bay, England, and works as a biology lecturer.

David Lloyd is the author of ten books, including three poetry collections: *Warriors* (Salt Publishing), *The Gospel According to Frank* (New American Press), and *The Everyday Apocalypse* (Three Conditions Press). His poems have appeared in *Crab Orchard Review, Denver Quarterly, DoubleTake,* and *Planet.* He directs the creative writing program at Le Moyne College in Syracuse, New York. SUNY Press will publish his new story collection, *The Moving of the Water,* in September 2018. His website is davidlloydwriter.com.

Nancy Lord, a former Alaska Writer Laureate, is the author of several fiction and nonfiction books, including *Fishcamp, Beluga Days, Early Warning,* and most recently, *pH: A Novel.* She teaches in the University of Alaska system and in the Johns Hopkins science writing program. Her website is writernancylord.com.

Jane Lovell won the Flambard Prize in 2015 and has been shortlisted for the Basil Bunting Prize and the Wisehouse International Poetry Prize. Her pamphlet *Metastatic* will be published in 2018 by Against the Grain Press. Her website is janelovell128.wixsite.com/janelovellpoetry.

Mark Luebbers teaches English and poetry in Cincinnati, Ohio. His poems have appeared in *The Apple Valley Review, Kudzu House, The Wayfarer,* and *Wilderness House Literary Review.* Mark's collaborations with Benjamin Goluboff will be published this summer in the anthology *They Said,* published by Black Lawrence Press.

Sara Massidda is a student of modern literature at the University of Cagliari in Italy. She enjoys drawing with traditional and digital media, and she especially loves watercolor pencils and inks. In her work, she aims to represent her curiosity towards different species of trees, mushrooms, and other life forms. She shares her works online under the name TheUnconfidentArtist.

Irene Hardwicke Olivieri paints about love, relationships, and obsessions—parts of life that are often subterranean. Her work explores transformations and rewilding the heart to inspire deeper connections to wild animals and wild lands. After years of living off the grid in Oregon and then Arizona, she recently moved to the coast of Maine.

Judith Skillman is interested in feelings engendered by the natural world. Her medium is oil on canvas and oil on board; her works range from representational to abstract. Her art has appeared in *Minerva Rising, Cirque, The Penn Review,* and *The Remembered Arts.* She studied at the Pratt Fine Arts Center and the Seattle Artist League. Her website is jkpaintings.com.

Carol Steinhagen took early retirement from a professorship at Marietta College to try the untenured life of a poet. She teaches courses combining her favorite subjects, literature and history, and takes classes in alien subjects like physics at the local Learning in Retirement program.

Heather Swan's creative nonfiction has appeared in *Aeon, ISLE, Resilience, About Place,* and *Edge Effects.* Her poetry has appeared or is forthcoming in *Poet Lore, Raleigh Review, Phoebe, Basalt, Midwestern Gothic, Cold Mountain Review,* and *Cream City Review.* Her book *Where Honeybees Thrive: Stories from the Field* was published by Pennsylvania State Press in 2017. She teaches at UW-Madison.

Natalie Tomlin is a freelance writer based in Grand Rapids, Michigan. Her recent nonfiction, poetry, and journalism have appeared or are forthcoming in *J Journal, Diode, Midwestern Gothic, Literary Mama, Rapid Growth Media,* and *NewPages.*

Leath Tonino is a freelance writer and the author of a forthcoming book of essays, *The Animal One Thousand Miles Long.* Born and raised in Vermont, he has also lived

and worked in Arizona, California, and Colorado, with shorter stints in New Jersey and Antarctica.

Brigit Truex's First Nations (Abenaki/Cree), French Canadian, and Irish heritage inform her sense of the spiritual inherent in nature. She has written four chapbooks and a full-length book, *Strong As Silk* (Lummox Press). Her poetry can be found in *I Was Indian*, *Atlanta Review*, *Canary*, *Yellow Medicine Review*, *PoetryNow*, and *Tule Review*. Brigit was runner-up for the 2017 Locked Horn Press Poetry Prize.

Bathsheba Veghte received her BA in fine arts from Bowdoin College. She has worked as a printmaker and was an artist in residence at the Kala Institute in Berkeley. Her work is in the Permanent Collection of the San Francisco Museum of Art as well as in many collections on both coasts. She is currently exploring paintings on aluminum, a surface she finds exciting both for its rendering of luminosity and smoothness of surface. Her website is bathshebaveghte.com.

Amy Weldon, a native Alabamian, is professor of English at Luther College in Decorah, Iowa, and the author of *The Writer's Eye* (Bloomsbury, 2018) and *The Hands-On Life* (Cascade, 2018). Her essays, short fiction, and reviews have appeared in *Orion*, *The Common*, *About Place*, *Los Angeles Review of Books*, and a variety of edited collections. She blogs on sustainability, spirit, and self-reliance at cheapskateintellectual.wordpress.com.

Maya White-Lurie's writing has been published internationally in various journals and chapbooks. She lives in Concepción, Chile, where she teaches English and writes every day. Her website is mayawhitelurie.wordpress.com.

Jess Williard's poems have recently appeared or are forthcoming in *Third Coast*, *North American Review*, *Colorado Review*, *Southern Humanities Review*, *Barrow Street*, *Lake Effect*, *New Orleans Review*, *Sycamore Review*, *Bayou Magazine*, *Iron Horse Literary Review*, and *The McNeese Review*. He is from Wisconsin. His website is jesswilliard.com.

Patrick Zephyr grew up in Fall River, Massachusetts, where he spent his childhood searching for amphibians, reptiles, and insects and exploring other hidden natural treasures. He is an award-winning nature photographer, and his photographs are displayed throughout New England and have been published widely. Patrick resides in Pelham, Massachusetts. His website is patrickzephyrphoto.com.

CPSIA information can be obtained
at www.ICGtesting.com
Printed in the USA
LVHW07s2116180918
590594LV00005B/5/P

9 781732 266254